This book belongs to

Copyright by Mom&Me Publishing

All rights reserved. This book or any portion thereof may not be reproduced or used in any manner whatsoever without the express written permission of the publisher except for the use of brief quotations in a book review. Recording of this publicationis strictly prohibited and any storage of this document is not allowed unless with written from the publisher. All right reserved.

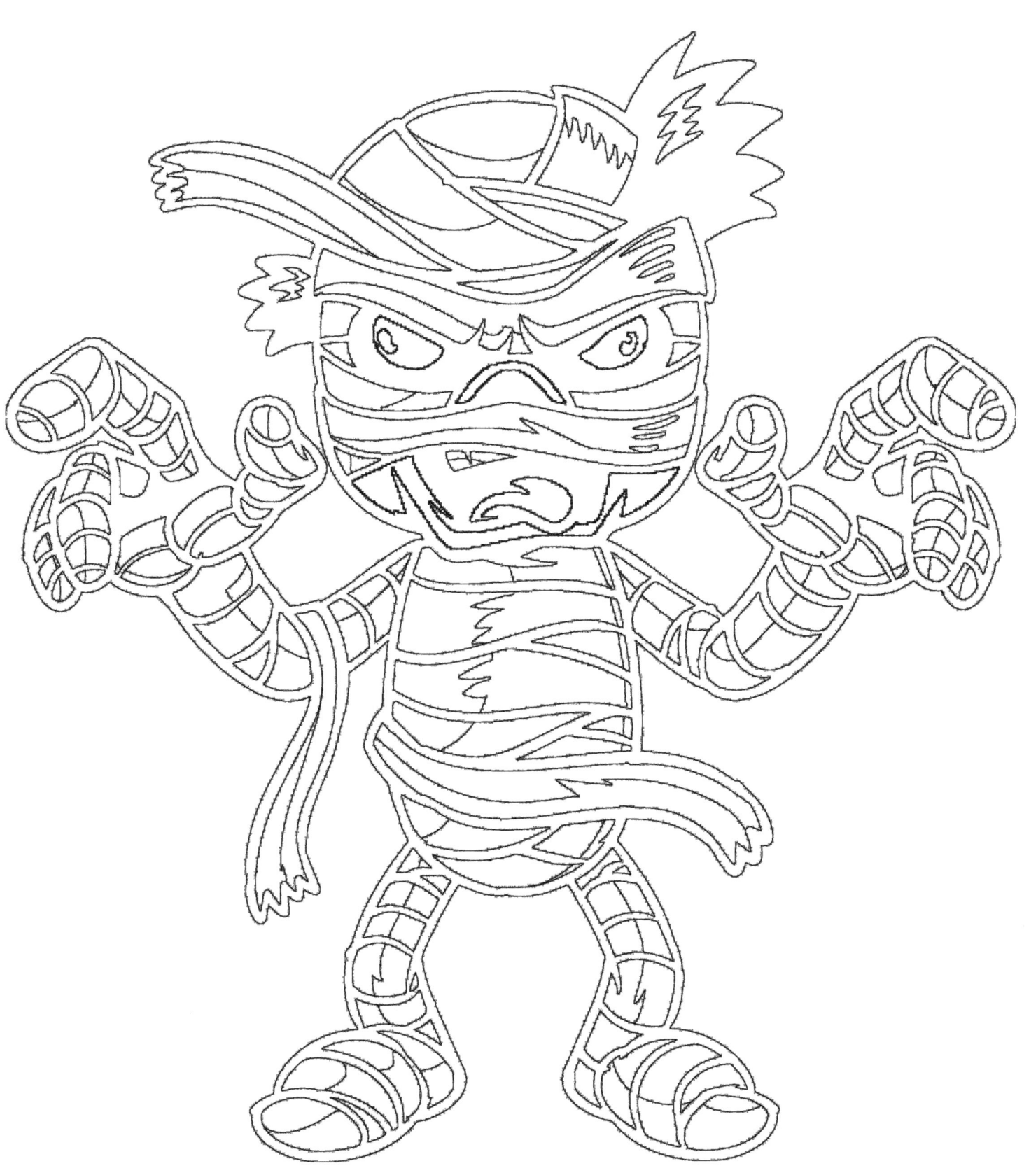

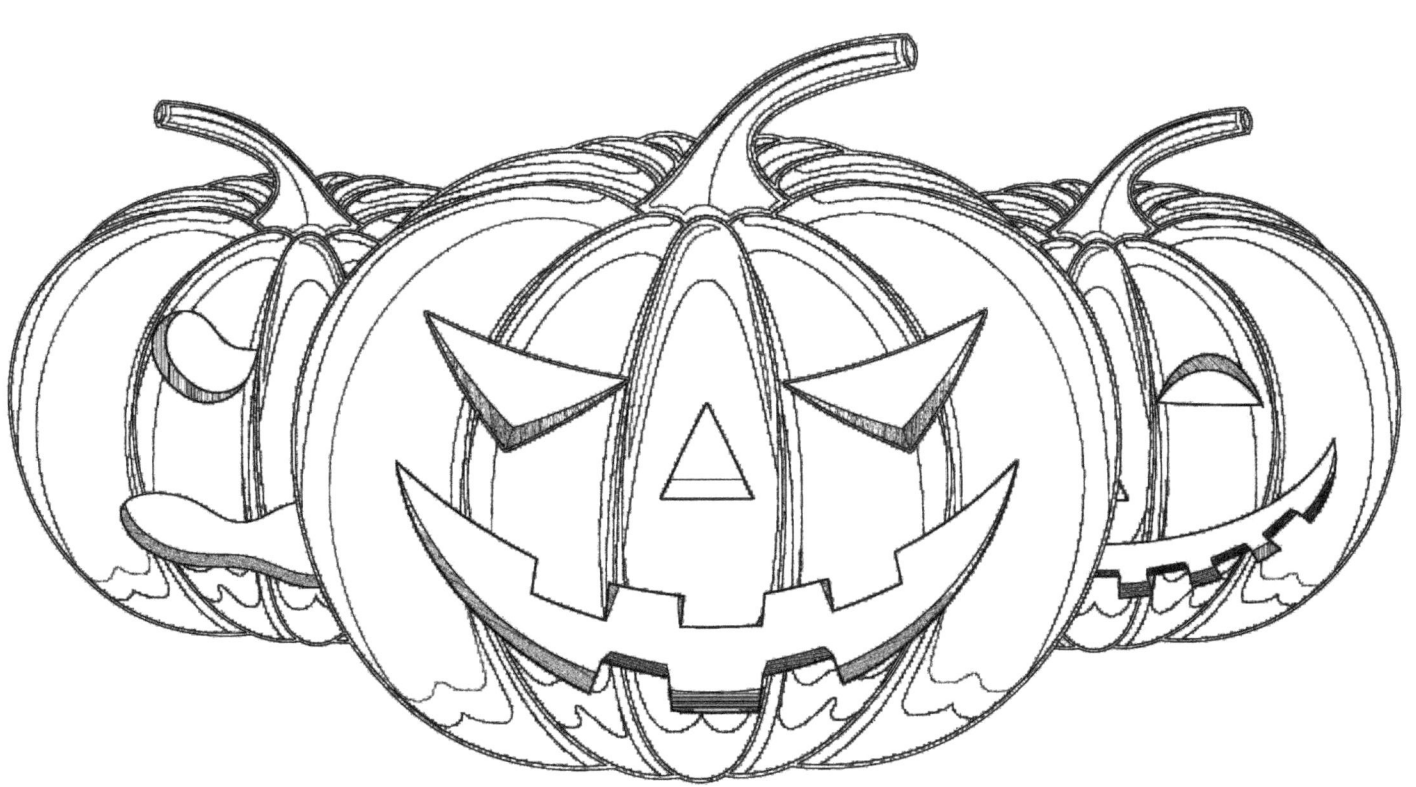

www.ingramcontent.com/pod-product-compliance
Lightning Source LLC
Chambersburg PA
CBHW080604220526
45466CB00010B/3248